AD REINHARDT

Seventeen Works

SEPTEMBER 22 – DECEMBER 16, 1984

AD REINHARDT

Seventeen Works

JANE LIVINGSTON

THE CORCORAN GALLERY OF ART

WASHINGTON, D.C.

The process of forming a private collection differs markedly from the process of forming a museum collection. Museums work within the framework of their historical mission, and collections grow incrementally. There is a need to be complete, rational and comprehensible in a museum collection. Normally, the act of private collecting is more personal, indeed more individual. Some of the very best private collections are energetic expressions of the eye of the collector. Most often we enjoy the sheer energy that such a highly personalized process generates. And within that context we admire the brilliance of individual acquisitions—for their quality, perceptiveness, and importance.

On rare occasions, a private collection is formed with such knowledgeability and perceptiveness that it has the weight of a museum collection. Such is the case with Gilbert H. Kinney's collection of Ad Reinhardt paintings. A good collector with a good eye could very well have acquired some of these extraordinary paintings. But the achievement here goes beyond that. What is so impressive is the discipline and knowledge that led to the assembling of the body of work that you see here. Each painting perfectly reveals another chapter in Reinhardt's development. Each painting is very much the best example that one could find of that type of Reinhardt's work. Each painting has a strong individual quality that makes it stand well on its own, but the sum is greater than the parts. It is a remarkable achievement in collecting to so fully capture the essence of an artist's work. Gilbert H. Kinney has assembled a collection that conveys that essence, and in doing so has demonstrated his own remarkable acumen.

Michael Botwinick

Why Ad Reinhardt? Collectors tend to divide into two camps, those who collect one or two works by a wide range of artists within their particular area of interest and those who collect in depth a few artists to whom they are particularly attracted. I have long favored the former approach with one notable exception, the paintings of Ad Reinhardt.

What led me to make an exception with Reinhardt? The answer lies in large measure in the comment by Jane Livingston on the works in this exhibition, but first a bit of background.

It began for me in 1974 with my first in depth exposure to Reinhardt. At the time I was beginning to collect American art of the New York School. An exhibition in New York featured the early works of Reinhardt who had died seven years before and was already well-known for his black paintings, the product of the last decade of his life. There was for me the joy of discovery which excites collectors whether it be coming upon a budding young artist or a hitherto unrecognized artist of the 18th or 19th century. Ad Reinhardt had been a central figure in American art circles for decades both as an intellectual spokesman for the arts and as an accomplished artist, but his work, aside from the final phase, was perhaps better known and more exhibited in Europe than in the United States, certainly outside of New York.

There is a more important reason why I was drawn to Reinhardt. Few artists can sustain a consistently high level of quality combined with an evolvement in style and technique which maintains constant interest in their work. There is great variety in Reinhardt's oeuvre just as his monochromatic paintings, red, blue or black, on close examination (and properly lit) turn out to be not monochromatic at all. As Jane Livingston points out, the paintings in the exhibition were chosen one-by-one on the basis of their "individual presence and quality as abstract works of art". Yet together I believe they form an impressive body of work by an artist who was central to that creative generation known as the New York School, a member of one of the great art movements of all time. I hope that others will share my enthusiasm for Ad Reinhardt and will enjoy this small selection of his work.

Gilbert H. Kinney

Ad Reinhardt would have been gratified to see the present assembly of his paintings, a group of works whose rationale for being together was based in a series of judgements about their individual presence and quality as abstract works of art. It is almost a matter of luck that they comprise a nearly perfect recapitulation of the main points of the artist's traversal. For Reinhardt was a strikingly uncompromising and paradoxical man, an artist who while insisting on the primacy of the uninterpreted, non-editorialized, uncontextualized, non-signifying, *object in itself*—nevertheless proceeded restlessly for most of his adult life, to write and teach and speak about art, his own and others, and to polemicize ceaselessly even while creating the most imperturbably self-referent objects.

Reinhardt is one of the most thoroughly studied, anthologized, and quoted painters of his much-labored-over circle. Somehow his odd, simultaneously super-articulate and mute stance in the world has inspired many artists and historians to scrutinize his life work, often as though it held the very key to the still fascinating mystery of "Abstract Expressionist Painting" itself. Given his insistence on the necessity simply to look at the artist's product, not to allow gossip or theory to color the experience of the visual confrontation between viewer and painting, it is surprising to find the Reinhardt myth so fraught with overtones of argument.

Reinhardt seemed always to want to temper his unswerving ambition for artistic purity with his simultaneous commitment to irony, his lifelong unrelenting mockery of . . . what? Of *everything*. Of any sort of pretention, smugness, cultishness, of certainty itself. And yet he believed in absolutes. He loathed psuedo-biomorphism in art, and embraced instead a kind of deeply biological canonicity; for all his progressive cleansing away of extraneous gesture in his painting, Reinhardt increasingly performed artistic acts whose very essence was in a series of echoing gestures. The final black paintings, those flat plain icons harboring crossed bars of subtlest visual incidence, signify the artist's own culminating decision: *barely to distinguish* is enough.

The Gilbert H. Kinney collection of Reinhardts takes us virtually the entire way through the artist's central journey. In at least one sense Reinhardt is the quintessential collector's artist, in that his progression, episode by episode, can be both experienced accurately and encapsulated manageably by gathering together the processional examples of the oeuvre (never, of course, an easy task). This collection touches every major period of Reinhardt's oeuvre. While being varied and even at times whimsical in its offshoots, the main Reinhardt production marches in a distinct array of styles, and it is partly in this processionality that the work reveals itself. Viewing this carefully fashioned cross-section of Reinhardt's work,

one can learn a great deal about the very enterprise of evolving as a visual thinker. To be a serious thinker about basic formal values: this was established both didactically and practically in the creative endeavors surrounding the artist. One moved through a certain dialectic, typically from the "painterly" or "gestural," toward the "conceptual" or, in Ad Reinhardt's case, the radically reductive.

Certainly Ad Reinhardt partook of his time; he distilled, both in his art and rhetoric, his own psychic environment. To follow his paintings from 1939, when the artist was twenty-six, to 1962, five years before he died, is to reexamine that time. It is also to examine a successful synthetic achievement—that is, a resolution out of the young artist's dualisms of analytic vs. accretive, or harmonious vs. assonant, into artistic synthesis. If much has been made of the "last resolution" of Reinhardt's adventure in the late black paintings, every new overview of the complex sequence of aesthetic acts leading to the late reductive episode provides a fascinating exercise in the dialectic of painting.

The earliest works in the Kinney collection are two small gouaches, (cat. no. 1) dating from 1939 and clearly adverting to several of the ascendant American abstract painting conventions of their era. These works are essentially cubist-derived compositions, reminiscent in their chromatic and formal aspects of such contemporaries as Stuart Davis or G.L.K. Morris, but even at this early stage, distinctive to their author. The off-primaries which comprise the palette here and in so much of Reinhardt's subsequent work—those richly varied greens and violets—begin here to be mastered, in the spirit of Albers' or Hofmann's insistence on chromatic mastery. We notice in these little pieces traces of both figural and city-scape derivations, but already most evident is the fundamental commitment to *abstract formal play* that will characterize the painter henceforward.

Purple Abstract, (cat. no. 2) of the next year, is a flatter composition now more recollective of Albers than Davis or someone like Juan Gris. This puzzle-piece composition reminds us more of the sculptural values of Archipenko and Lipchitz than of any other cubist painter. It is a small, yet finished work, gem-like and rather conservative in nature, a piece inconceivable without Bauhaus-derived aesthetic values. We are given a prime example of Reinhardt's early conquest of his necessarily-digested modernist vocabulary.

The whimsical yet potent paper collage of 1943, (cat. no. 3) one of several done at this moment in the artist's still formative and drivingly inventive stage of development, conveys Reinhardt's always-latent gestural and manipulative instinct as an artist. Here we see an unusually overt example of the artist as the irrepressible provocateur he remained. The cubist/constructivist/Dadaist layerings

of reference here distill, in a sense, the very substance of Reinhardt's acutely sophisticated nature as an artist. What is so astonishing in a piece like this small collage is not its eclecticism—for it is essentially eclectic, an object like innumerable objects made by his peers across the field in the early 1940s—but its present power to move us as an isolated entity. Whatever else it is, this is an active thing, modest, quick, slyly affecting.

Perhaps one of the most serenely anomalous works of the artist's entire output—a picture whose intense individuality marks it as a fascinating (and prophetic) touchstone in recent American art—is the untitled "White Painting" of 1945 (cat. no. 4). This smallish work is an odd and yet fully realized minor masterpiece, whose imagery, a kind of stiff, carefully forged abstract sign language, combines with a slim yet rich palette, creating an endlessly complex and enigmatic phenomenon. It has none of the painterliness or gesturalism of most of the artist's other works of this period; it is neither openly surrealist-derived nor cubist in spirit; it refers obliquely to Klee, perhaps to Mondrian or Van Doesburg, but it is fundamentally a piece which looks forward, pointing to Jasper Johns. The "White Painting" is conceived as a sort of hieroglyph, worked into a finely textured surface, barely imbued and overglazed with a rainbow-like veneer of palest color, color arranged like a washed vertical progression, left to right, cold to warmer. It is a precursor of 1960s and 70s structuralist-inspired painting, as well as an inheritor of the Bauhaus-associated episode of ideographic objects. This work is symptomatic of its author's capacity to commit an occasional gratuitous act which suddenly exposes an impossible new depth of audacity, self-knowledge, *otherness*.

That the next work in this chronological selection happens to be one of the most extroverted, busily cerebral, even quasi-calligraphic works in the painter's entire oeuvre, dramatizes by contrast the anomalousness of the "white one." *Blue Abstract* of 1947 (cat. no. 5) exposes the covert draughtsman/cartoonist side of the artist's personality in a work whose conscious nature and intent is not peripheral but seriously oeuvre conscious; looking at this, we are not surprised to know that Reinhardt was innately a scribbler, a draughtsman capable of endless doodled scraps, and creator of numerous satiric illustrations. The sense here of urban architecture, or at least of a vaguely cubist landscape reference, reminds us both of Mondrian and Stuart Davis—yet, by now, Reinhardt has fully matured his own distinctive touch and spatial grasp, already thinking schematically in terms of the grid.

Abstract Paintings #1 and *#2* (cat. nos. 6 and 7) together show the artist at the height of his restlessly experimental powers, using oil paint first to create an

almost watery, soaked effect, rather like the magna paint first used twenty years later by Helen Frankenthaler and Morris Louis; and then, abjuring the soft, blurred effects of #1, returning to the spidery, frenetic approach in which Reinhardt's characteristic tension across the picture surface between drawing and painting, asserts itself. The palette of these works, engaging the entire warm spectrum, and the stained-glass compositions invoke a rather uncharacteristically expressive and even Baroque repertory of pictorial devices: these works, while modest in size, project a kind of extroverted intensity, a rather garrulous and engaging quality rarely found in Reinhardt's oeuvre.

Blue-Green Painting of 1948, (cat. no. 8) nearly seven feet in height and treated compositionally like a purely geometric, chromatically limited, and essentially flat surface, represents the instant of break-through into the prophetic drive toward the minimal that Reinhardt would gradually solidify until his death. This work is both disciplined to the point of austerity and, in its way, surpassingly lyrical. It is *about blue and green*, yet not as in Albers or Hans Hofmann: unlike his precursors Ad Reinhardt explored and instructed in matters of color perceptivity, without being didactic or in any way mechanical. This work, so startling in its time, seems now as fresh, as poetic and directly emotive, as any work created since. It foreshadows many aspects of the later work; its surface takes on that peculiarly matte, even arid quality that will characterize so many of the great succeeding paintings; its brick-wall compositional structure will resonate not only in the artist's own future but in the development of painting and sculpture for the next fifty years. We can find here allusions ranging from late Monet to Sol LeWitt.

In 1948–49, Reinhardt executed a number of works so explicitly calligraphic as to be almost paradigms for a painting of gestural signs. It has been shown persuasively that these works parallel a progression in Mondrian's development more than thirty years earlier—but Reinhardt was working toward quite a different end in his deployment of calligraphic units on canvas. The Kinney Untitled Abstract Painting (cat. no. 10) (the most recently acquired of this group) is one of the most successful pieces ever made by the artist. Its paradoxic combination of material sparseness, dryness, and compositional intricacy make it a work at once difficult and sensually gratifying. Reinhardt appeals both to our intellect and our visceral responsiveness; never did he better fuse these two concerns than in the painting at hand. This is an oddly *communicative* canvas, a perfectly contained, masterfully balanced entity whose sense of closure and completely resolved logic give us the kind of pleasure to be derived in achieving new synthetic insights, or in mathematical learning.

The small gouache, #26, (cat. no. 10) painted in the next year, stands as a sort of small, jewel-like piece expressing all of the consummate ease and sensuous revelry of which the artist is capable, seen now as a kind of release from, or antidote to, the mountingly arduous and innovative and hard-won accomplishments of Ad Reinhardt's imminent proto-reductivist cycle of paintings. Here again, we are struck by the precocious "bleeding" of paint, heralding the "post-painterly abstractions" of the generation twenty to thirty years his junior.

Again with the next picture, (Untitled) (cat. no. 11) executed in 1950 and employing an even more exaggerated vertical proportion than its predecessor here, we find the artist dealing with the rectilinear puzzle-piece format, placing blocks of color into one matrix so that they work as an all-over interreactive irregular grid. This work meshes a relatively varied color scheme with a simple cruciform shape gestalt. It is a prime example of the paintings dating from the cusp of the late 1940s and early 50s which truly establish Reinhardt as the most precocious and committed minimalist, or abstract/iconic, painter of his time. This piece also incorporates one of Reinhardt's distinctive, indeed virtually unique, palette ranges, that embracing the violet-to-blue-green spectrum, now so synonymous with his style.

The nearly contemporaneous *Red Painting*, (cat. no. 12) a much looser and more unashamedly painterly work than the last, seems to express a final almost wistful desire to re-engage the figure-ground duality so excruciatingly difficult for every abstract painter of the time to purge from their canvases. The dominant reds lie in front of a hinted-at dark green back-plane: strokes of paint, daubs whose nature asserts itself into one perfectly opulent pictorial web. We move from here to *Red Wall* of 1952, (cat. no. 13) a painting whose relative coolness, whose more rigid discreteness and linearity, yield a highly assertive constructivist presence. Such a painting inevitably vibrates with a strong retinal tension. This may indeed be one of Reinhardt's most definitively optical works—its brittleness and ceremony remind us of the full measure of pageantry which the artist could so easily summon, and so rarely did. Together these two red paintings can be said to epitomize an important factor of Abstract Expressionism's deepest dynamic: grandeur, sheer physical overtness, chivalry of gesture, could, within American avant-garde painting of the early 1950s, prevail over the other main aesthetic tendency of the movement—that urge toward a burrowing physical secrecy, that endless narcissistic introversion found in so many of his peers. Reinhardt, for all his polemical complexity and denial of societal/artistic values, could be serenely public, celebratory, decorous in his endeavor.

From the two heated red paintings, one advances to the two blue ones of 1953, (cat. nos. 14, 15) both now contained, bilaterally symmetric, sedate. The blue paintings, for all their intensity of chroma and relatively dramatic internal varie-gations, nevertheless herald the black ones to follow. In the larger of the two Kinney blue paintings, we witness Reinhardt's distinctive grid/plaid color scheme in its most fully developed form: this work, in its strong vertical thrust, and with its barely distinguishable value contrasts, yet clearly distinguishable hues, is a sort of culminative achievement in terms of the artist's mastery of color.

He made notes during this period on what he called "color symbolism":

> "red, fire, blood, hot riot, revolution, passion, energy, fear,
> jealousy, deceit
> scarlet
> "blue—'color of villains, ghosts and fiends'
> hope, heaven, sky
> black
> heroism, patriotism
> criminal death, doom, darkness[2]

These thoughts are emphatically *un*connected to Reinhardt's artistic intentions. He was careful not to ascribe any such symbolism to anyone's experience of his painting. He insisted throughout his life as a painter that his work was about itself. The blue paintings here testify to the success with which Reinhardt neutral-ized, or obfuscated, any literary overtones in the act of their experiencing; cer-tainly neither the red nor, even more emphatically, the blue ones, conjure to mind any of the emotions or stereotypes mentioned in his notes.

The 40″ x 40″ red painting from 1953, (cat. no. 16) executed in the most obvious and contained of formats, belongs to the painter's brief classical phase, that interval when he made both red and blue perfectly square canvases, each containing square-referent internal divisions. This work, like the other red ones, manages despite its inevitable warmth, to convey an entirely non-literary and unemotive character while being somehow decorative in the highest sense.

The last work, *Black Painting*, 1962, (cat. no. 17) 60 inches square, is one of several of this size and scale executed in 1962 and 1963. Much has been written about these final dark works whose compositional simplicity and nearly irreduci-ble palette have incited suspicions of nihilism and denial or renunciation. But given the events leading up to these paintings, and in light of the artist's careful emphasis on his constant intention *only to make paintings*, to conceive and

execute objects whose essence and integrity is absolutely self-evident, we understand this black painting to be a sort of triumph of resolution and affirmation. The inexplicable richness, the fullness of substance and luxuriance of facture inhabiting this pristine piece, testify to their maker's supreme mastery of his medium. We know unmistakably the hand and eye of an original and exhaustively practiced colorist in his nominally "colorless" and incipiently "featureless" object; its energy springs from its simple rightness of scale, geometry, pigment, in the service of what can only be called the collective abstract conscious of Ad Reinhardt's era.

<div align="right">Jane Livingston</div>

1. Margit Rowell, *Ad Reinhardt and Color*, The Solomon R. Guggenheim Museum, New York, 1980, pp. 18–21.
2. *Ibid.*, p. 24 (from Barbara Rose, ed., *Art as Art: The Selected Writings of Ad Reinhardt*, New York, 1975.)

1. *Two Gouaches*, 1939

Gouache on paperboard
9⅜ x 7¼" (24.0 x 18.3 cm.)
9⅜ x 7⅛" (24.0 x 18.2 cm.)

Provenance

Purchased from Marlborough Gallery, Inc., New York, March, 1974
Mrs. Rita Reinhardt/Estate of the artist

Exhibition Record

The Jewish Museum, New York, "Ad Reinhardt: Paintings,"
November 23, 1966–January 15, 1967. Cat. #7, illustrated in black
and white.

Städtische Kunsthalle, Düsseldorf, "Ad Reinhardt," September 15–
October 15, 1972, Cat. #4, illustrated in black and white, p. 22;
Stёdelijk van Abbemuseum, Eindhoven, December 15, 1972–
January 28, 1973, Cat. #4, illustrated in black and white, p. 16;
Kunsthaus Zürich, February 11–March 18, 1973; Galeries
nationales du Grand Palais, Paris, May 22-July 2, 1973, Cat. #4,
illustrated in black and white, p. 22; Museum des 20 Jahrhunderts,
Vienna, July 18–September 22, 1973.

Marlborough Gallery, Inc., New York, "Ad Reinhart: A Selection
from 1937 to 1952," March 2–23, 1974, Cat. #3, illustrated in
black and white, p. 14.

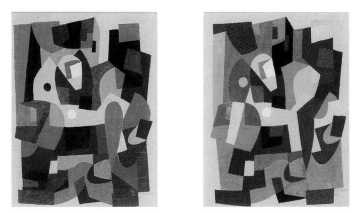

2. *Purple Abstract*, 1940

Oil on canvas
9 x 24″ (22.8 x 61.0 cm.)

Provenance

Purchased from Ira Spanierman, Inc., New York, November, 1979
Alex and Jean Turney, New York

3. *Untitled*, 1943

Collage and gouache on paperboard
16 x 20″ (41 x 51 cm.)

Provenance

Purchased from Christies, New York, May, 1981
Mortimer S. Brandt

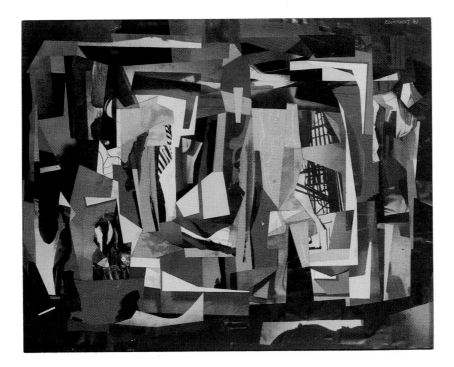

4. *Untitled (White)*, 1945

Oil on panel
17⅞ x 23⅞″ (45.3 x 60.7 cm.)

Provenance

Purchased from Marlborough Gallery, Inc., New York, March, 1980

Estate of the artist

Exhibition Record

Städtische Kunsthalle, Düsseldorf, "Ad Reinhardt," September 15–
October 15, 1972, Cat. #12, illustrated in color; Stedelijk van
Abbemuseum, Eindhoven, December 15, 1972–January 28, 1973;
Kunsthaus Zürich, February 11–March 18, 1973; Galeries
nationales du Grand Palais, Paris, May 22–July 2, 1973, Cat. #12,
illustrated in color; Museum des 20 Jahrhunderts, Vienna, July 18–
September 22, 1973.

Marlborough Gallery, Inc., New York, "Reinhardt: A Selection from
1937 to 1952," March 2–23, 1974. Cat. #11.

Marlborough Gallery, Inc., New York, "Ad Reinhardt (1913–1967),"
January 5–26, 1980.

5. *Blue Abstract*, 1947

Oil on board
24 x 46″ (61 x 66 cm.)

Provenance

Purchased from Ira Spanierman, Inc. New York, October, 1979
Alex Turney, New York

Exhibition Record

Betty Parsons Gallery, "Ad Reinhardt: Twenty-Five Years of
Abstract Painting," October 17–November 5, 1960, (no catalog
number), illustrated in black and white.

6. *Abstract #1*, 1948

Oil on canvas
32 x 39⅞″ (81.2 x 101.5 cm.)

Provenance

Purchased from Ira Spanierman, Inc., New York, October, 1979
Alex Turney, New York

Selected Bibliography

Lippard, Lucy R., *Ad Reinhardt.* New York: Harry N. Abrams, 1981.
Illustrated in black and white, p. 48, fig. 32 (Incorrectly dated as
1949).

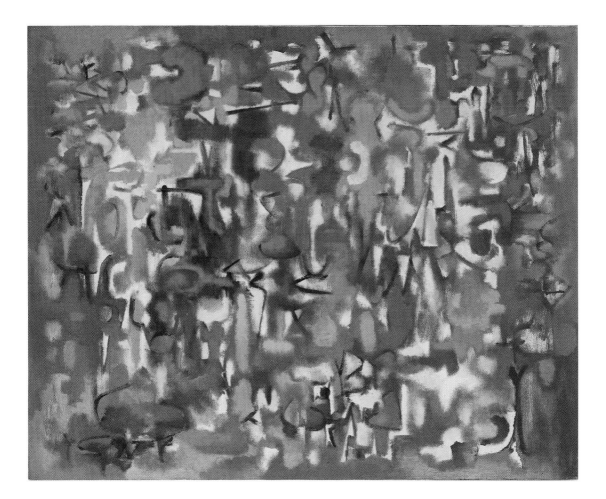

7. *Abstract #2*, 1948

Oil on canvas
31¾ x 40″ (80.7 x 101.6 cm.)

Provenance

Purchased from Ira Spanierman, Inc., New York, October, 1979
Alex Turney, New York

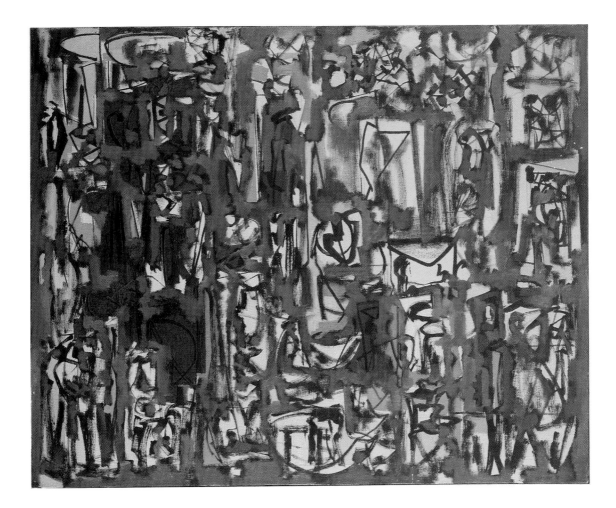

8. *Blue-Green Painting*, 1948

Oil on canvas
80 x 50″ (203.2 x 127 cm.)

Provenance

Purchased from Marlborough Gallery, Inc., New York, March, 1974
Mrs. Rita Reinhardt

Exhibition Record

Städtische Künsthalle, Düsseldorf, "Ad Reinhardt," September 15–
October 15, 1972, Cat. #20; Stedelijk van Abbemuseum,
Eindhoven, December 15, 1972–January 28, 1973; Kunsthaus
Zurich, February 11–March 18, 1973; Galeries nationales du Grand
Palais, Paris, May 22–July 2, 1973; Museum des 20 Jahrhundrets,
Vienna, July 18–September 22, 1973.

Selected Bibliography

Lippard, Lucy R. "Ad Reinhardt: One Art." *Art in America* Vol. 62,
5 (1974):65–75. Illustrated in color p. 66.

Sandler, Irving. *The Triumph of American Painting, A History of
Abstract Expressionism.* New York: Praeger Publishers, Inc., 1970.
Illustrated in black and white, p. 229, fig. 18–7.

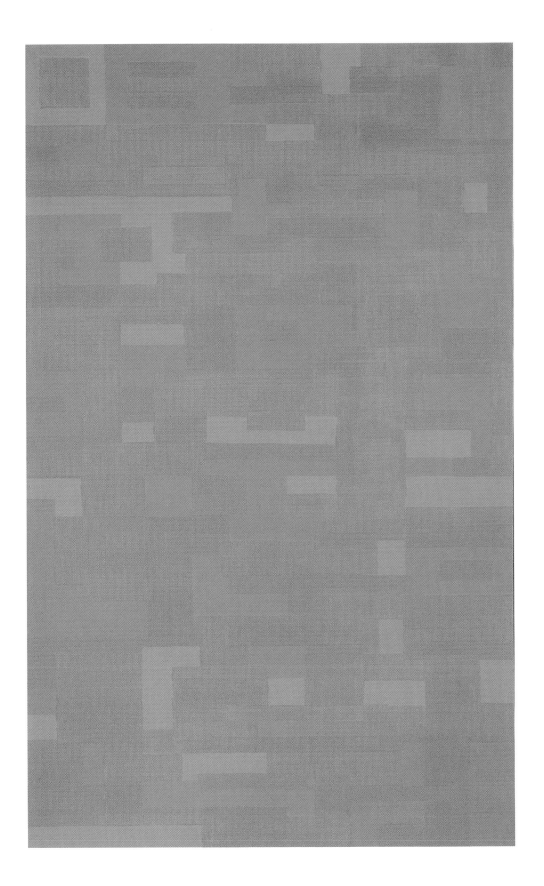

9. *# 26*, 1949

Gouache on paper
22½ x 30½" (57.0 x 77.5 cm.)

Provenance

Purchased from Christie's, November, 1983
Estate of Betty Parsons

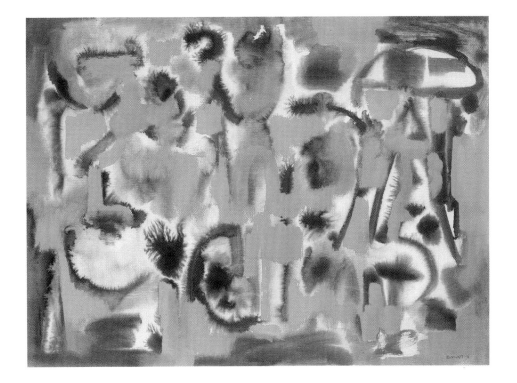

10. *October, 1949*

Oil on canvas
50 x 20″ (127 x 51 cm.)

Provenance

Purchased from Margo Leavin Gallery, Los Angeles, February, 1984

Collection Bernar Venet, New York

Betty Parsons Gallery, New York

Exhibition Record

Margo Leavin Gallery, "Ad Reinhardt: Paintings 1937–1952," February 23–March 24, 1984.

Selected Bibliography

Lippard, Lucy R. *Ad Reinhardt*. New York: Harry N. Abrams, Inc., 1981. Illustrated in black and white, figure 41.

Motherwell, Robert and Ad Reinhardt, eds., *Modern Artists In America: First Series*. New York: Wittenborn Schultz, Inc., 1951. Illustrated in black and white, p. 54. (Printed incorrectly in reverse.)

Rowell, Margit. *Ad Reinhardt and Color*. New York: The Solomon R. Guggenheim Foundation, 1980. Illustrated in black and white, p. 17.

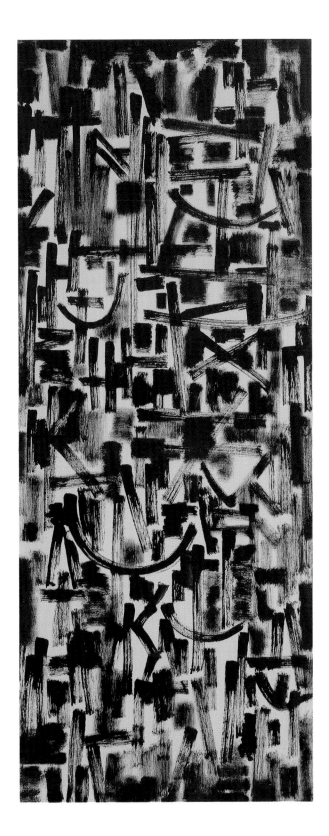

11. *Untitled*, 1950

Oil on canvas
60 x 18″ (152.4 x 45.7 cm.)

Provenance

Purchased from Marlborough Gallery, Inc., New York, January, 1974.

Estate of the artist

Exhibition Record

The Jewish Museum, New York, "Ad Reinhardt: Paintings," November 23, 1966–January 15, 1967. Cat. #50, illustrated in black and white, p. 71.

Städtische Künsthalle, Düsseldorf, "Ad Reinhardt," September 15–October 15, 1972, Cat. #33 (incorrectly identified as 34), illustrated in black and white, p. 27; Stedelijk van Abbemuseum, Eindhoven, December 15, 1972–January 28, 1973, cat. #33, illustrated in black and white, p. 18; Kunsthaus Zürich, February 11–March 18, 1973; Galeries nationales du Grand Palais, Paris, Cat. #33, illustrated in black and white p. 27; Museums des 20 Jahrhunderts, Vienna, July 18–September 22, 1973.

Marlborough Gallery, Inc., New York, "Reinhardt: A Selection from 1937 to 1952," March 2–23, 1974. Cat. #48.

Solomon R. Guggenheim Museum, New York, "Ad Reinhardt and Color," January 11–March 9, 1980, Cat. #2, illustrated in black and white, p. 30.

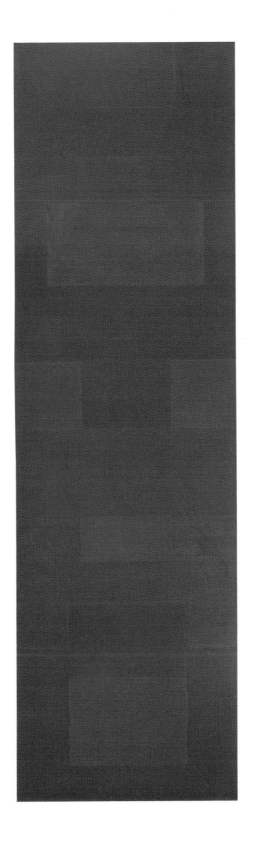

12. *Red Painting*, 1950

Oil on canvas
40⅛ x 32⅛″ (102.0 x 81.5 cm.)

Provenance

Purchased from Marlborough Gallery, Inc., New York, October,
1977

Exhibition Record

Städtische Künsthalle, Düsseldorf, "Ad Reinhardt," September 15–
October 15, 1972, Cat. #28; Stedelijk van Abbemuseum,
Eindhoven, December 15, 1972–January 28, 1973; Kunsthaus
Zurich, February 10–March 18, 1973; Galeries nationales du Grand
Palais, Paris, May 22–July 2, 1973, Cat. #28; Museum des 20
Jahrhunderts, Vienna, July 18–September 22, 1973.

Marlborough Gallery, Inc., Rome, "Ad Reinhardt," May, 1974.

Marlborough Gallery, Inc., Zürich, "Ad Reinhardt," December,
1974–January, 1975. Cat. #12. Cover illustration in color.

Marlborough Gallery, Inc., New York, "Ad Reinhardt: A Selection
from 1937 to 1952," March 2–23, 1974. Cat. #45.

Marlborough Gallery, Inc., New York, "Ad Reinhardt: Early Works
Through Late Black Paintings 1941–1966," October 15–November
12, 1977. Illustrated in black and white.

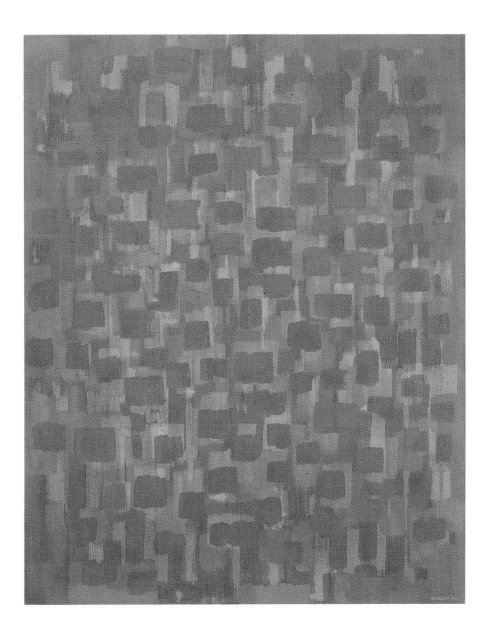

13. *Number 5 (Red Wall)*, 1952

Oil on canvas
80 x 42″ (203.2 x 106.8 cm.)

Provenance

Purchased from James Goodman Gallery, Inc., New York, March,
1983

Private Collection, Germany

Old National Bancorporation, Spokane, Washington

Betty Parsons Gallery, New York

The artist

Exhibition Record

Randolph-Macon Women's College, Ashland, Virginia, 46th
Annual, April–June, 1957.

Fine Arts Pavilion, Seattle's World Fair, "American Art Since
1950," April 21–October 21, 1962, p. 44, no. 55 (Number 5).
Traveled to: Institute of Contemporary Art, Boston, November 21–
December 23, 1962. Organized by The Poses Institute of Fine Arts,
Brandeis University, Waltham, Massachusetts, and Institute of
Contemporary Art, Boston.

Solomon R. Guggenheim Museum, New York, "Ad Reinhardt and
Color," January 11–March 9, 1980. Cat. #6, illustrated in black and
white, p. 36.

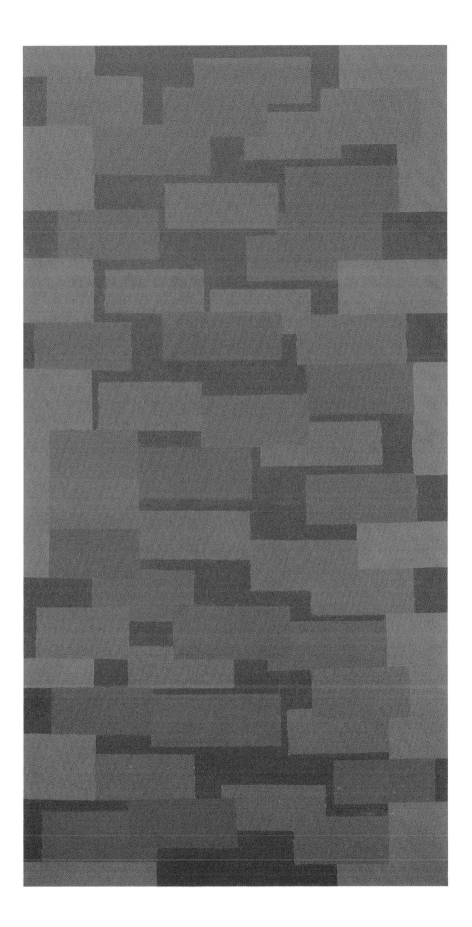

14. *Abstract Painting, Blue*, 1953

Oil on canvas
20 x 9⅞" (55.9 x 25.0 cm.)

Provenance

Purchased from Pace Gallery, New York, December, 1981

Margo Leavin Gallery, Los Angeles

Private Collection, Paris

John Mann, New York

Exhibition Record

Marlborough Fine Art, Ltd., London, "Masters of the 19th and 20th Centuries," April–May, 1972, Cat. #46, illustrated in color.

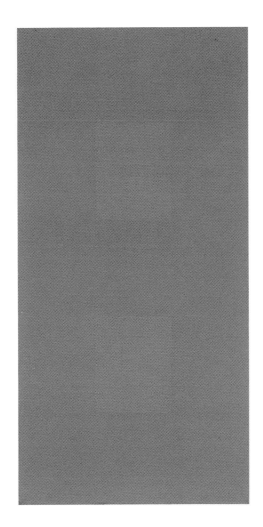

15. *Abstract Painting, Blue*, 1953

Oil on canvas
50 x 25″ (127.0 x 63.5 cm.)

Provenance

Purchased from Christies, New York, November, 1982

Abrams Family Collection

Stable Gallery, New York

Exhibition Record

Stable Gallery, New York, "Paintings, blue, 1950 to 1953," March–April, 1965

Galleria Odyssia, New York, "Seven Decades 1895–1965; Cross Currents in Modern Art," April 26–May 21, 1966. Abstract #53, illustrated, p. 149.

The Jewish Museum, New York, "The Harry N. Abrams Family Collection," June 29–September 5, 1966. Cat. #119.

The Solomon R. Guggenheim Museum, New York, "Ad Reinhardt and Color," January 11–March 9, 1980. Cat. #17, illustrated in black and white, p. 49.

Selected Bibliography

Lippard, Lucy R.: *Ad Reinhardt*. New York: Harry N. Abrams, Inc., 1981. Illustrated in black and white, p. 106, fig. 79.

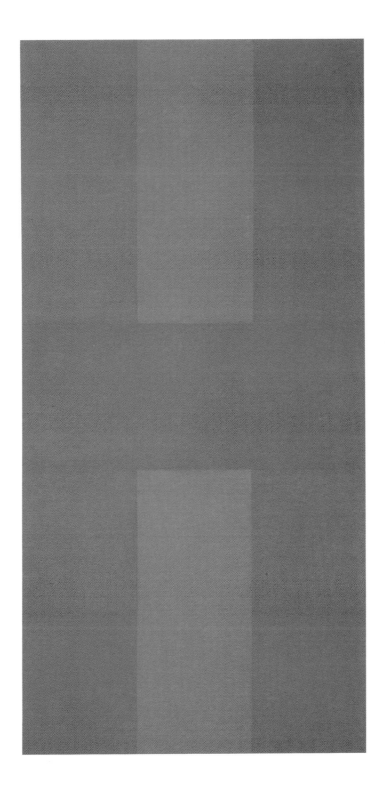

16. *Abstract Painting, Red,* 1953

Oil on canvas
40 x 40″ (101.6 x 101.6 cm.)

Provenance

Purchased from Marlborough Gallery, Inc., New York, September, 1974

Anna Reinhardt

Mrs. Rita Reinhardt/Estate of the artist

Exhibition Record

Graham Gallery, New York, "Paintings, red, 1950 to 1953," March 2–27, 1965.

The Jewish Museum, New York, "Ad Reinhardt: Paintings," November 23, 1966–January 17, 1967. Cat. #80, illustrated in color, p. 24.

Selected Bibliography

Lippard, Lucy R. "Ad Reinhardt: One Art." *Art in America* Vol. 62, 5 (1974):65–75. Illustrated in color, p. 74. (Graham Gallery exhibition installation photograph.)

Lippard, Lucy R. *Ad Reinhardt.* New York: Harry N. Abrams, Inc., 1981. Illustrated p. 101, Colorplate 19.

Selz, Peter. *Art in Our Times, A Pictorial History 1890–1980.* New York: Harry N. Abrams, Inc., 1981. Illustrated in color, p. 420, fig. 1145.

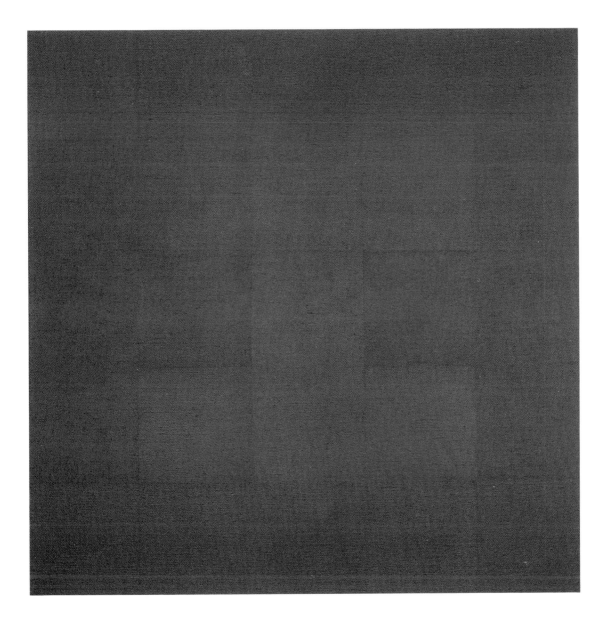

17. *Black Painting*, 1962

Oil on canvas
60 x 60″ (152.4 x 152.4 cm.)

Provenance

Purchased from Acquavella Contemporary Art, New York,
September, 1975

Private Collection, London

Private Collection, California

Dwan Gallery, Los Angeles

Exhibition Record

Dwan Gallery, Los Angeles, "All black Reinhardt show," 1963.

The Jewish Museum, New York, "The Black Square Room," 1966–
1967.

Marlborough Gallery, New York, "Ad Reinhardt: Black Paintings
1951 to 1967," March, 1970. Cat. #24.

Selected Bibliography

Lippard, Lucy R. "Ad Reinhardt: One Work." *Art in America*, Vol.
62, 6 (1974):95–101. Illustrated in black and white, p. 95. (Dwan
Gallery exhibition installation photograph.)

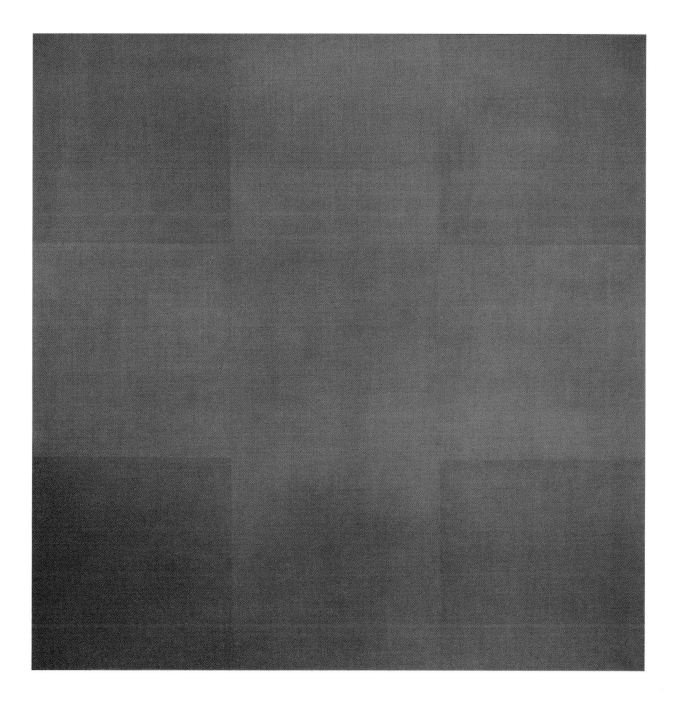

THIS CATALOGUE

was printed in an edition of fifteen hundred
by Schneidereith & Sons, Baltimore, Md.
Color separations were prepared by Prolith International, Beltsville, Md.
Design and typographical composition
by Alex & Caroline Castro, Hollowpress, Baltimore, Md.

———————————————————————————————

Library of Congress Cataloging in Publication Data

Reinhardt, Ad, 1913–1967.
 Ad Reinhardt, seventeen works.

 Catalog of an exhibition, Sept. 22–Dec. 16, 1984, Corcoran Gallery of
Art.
 1. Reinhardt, Ad, 1913–1967—Exhibitions.
2. Kinney, Gilbert H.—Art collections—Exhibitions.
3. Painting—Private collections—United States—Exhibitions.
I. Livingston, Jane. II. Corcoran Gallery of Art. III. Title.
ND237.R316A4 1984 759.13 84-17646
ISBN 0-88675-011-3